THE
WORM
AND
THE
BIRD

PENGUIN BOOKS

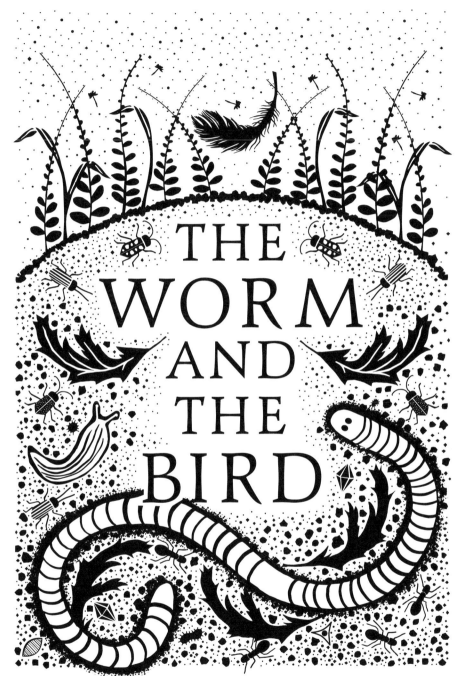

THE
WORM
AND
THE
BIRD

CORALIE BICKFORD-SMITH

for Tom

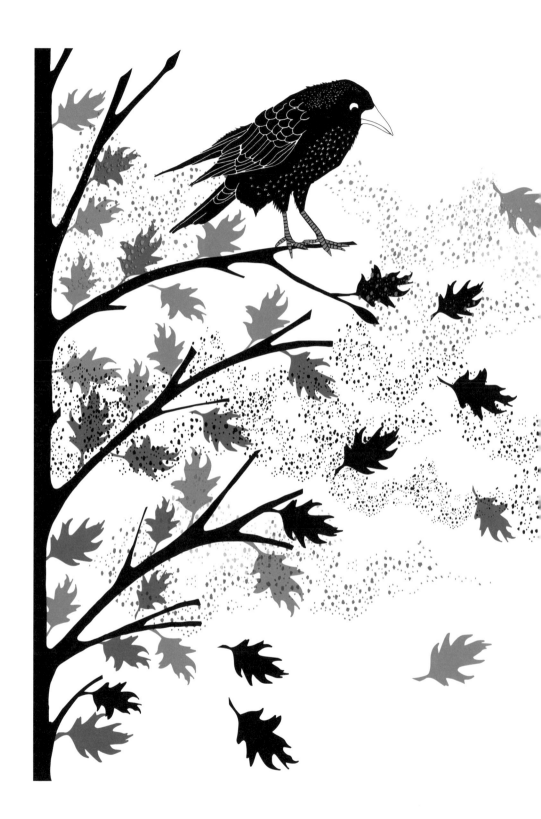

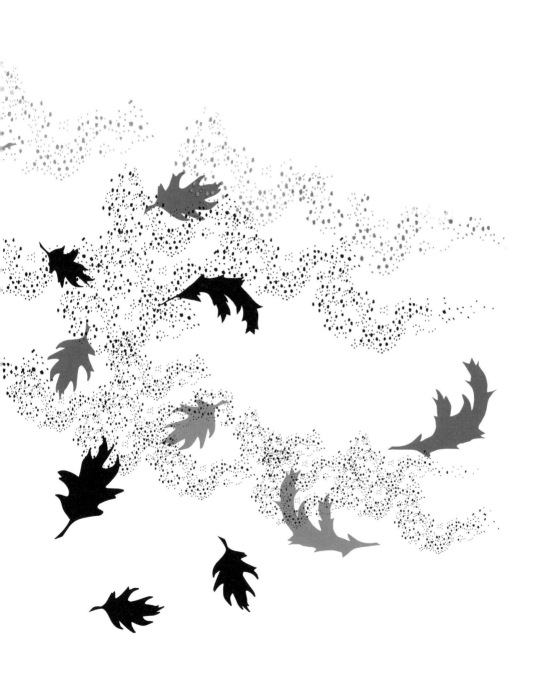

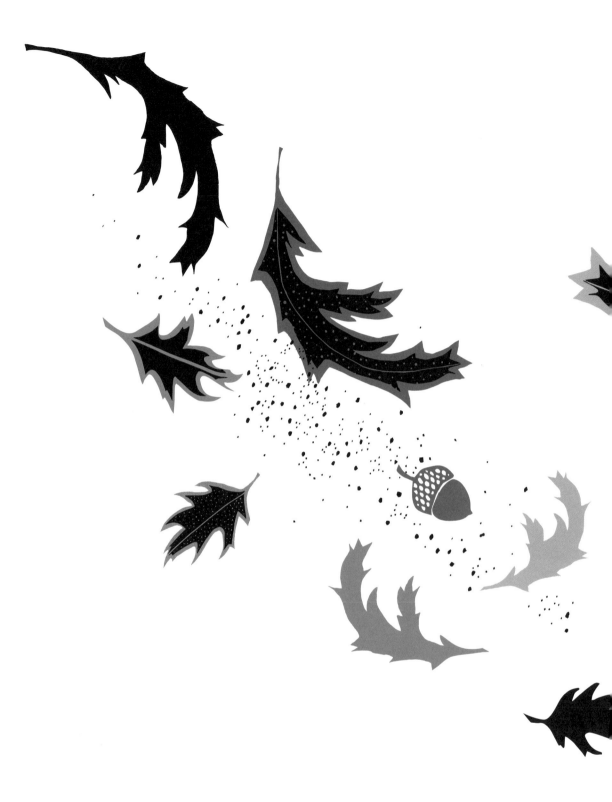

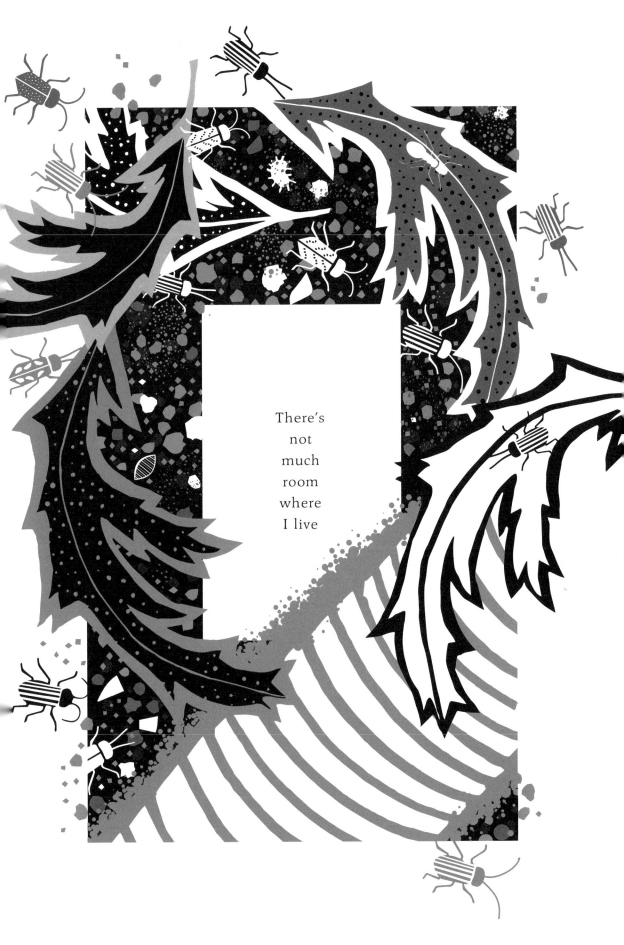

There's
not
much
room
where
I live

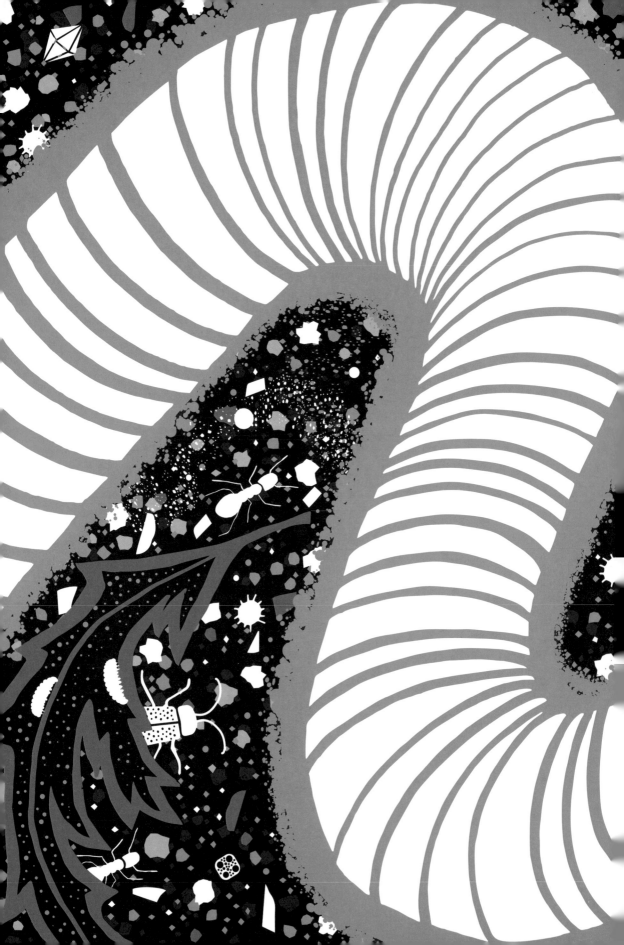

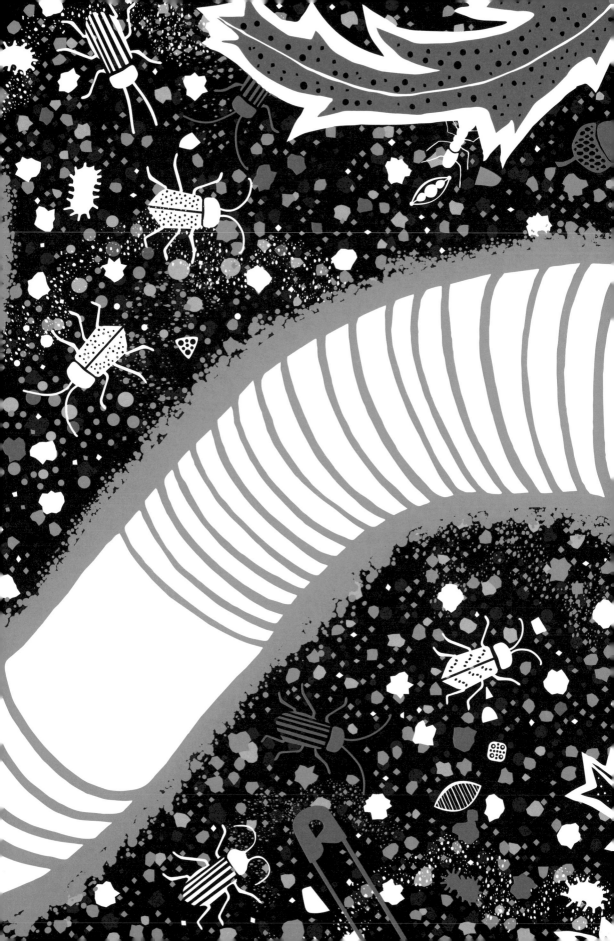

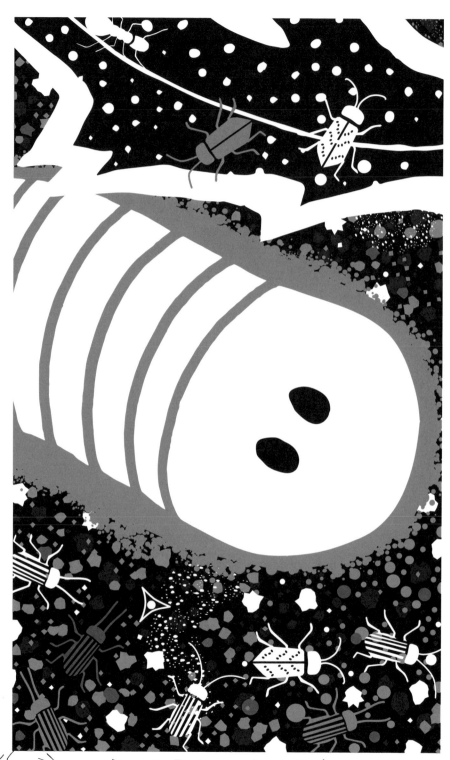

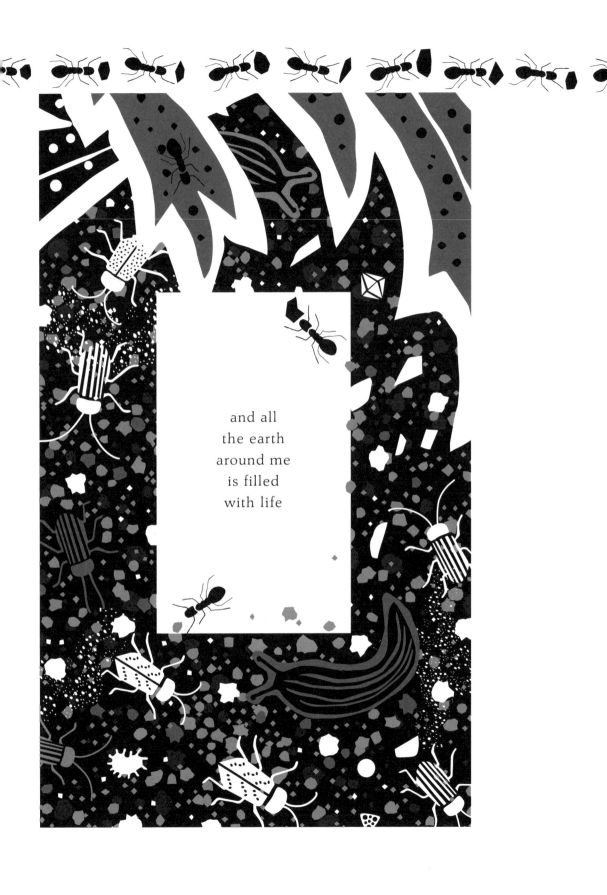

and all
the earth
around me
is filled
with life

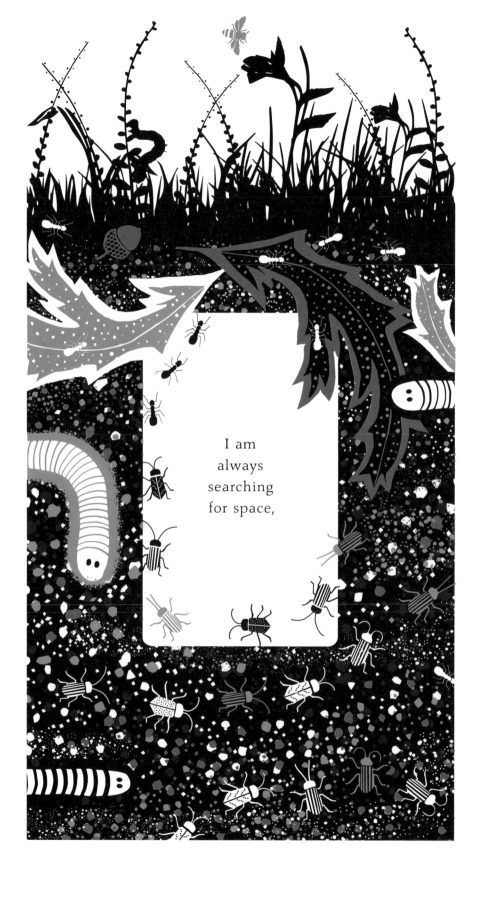

I am
always
searching
for space,

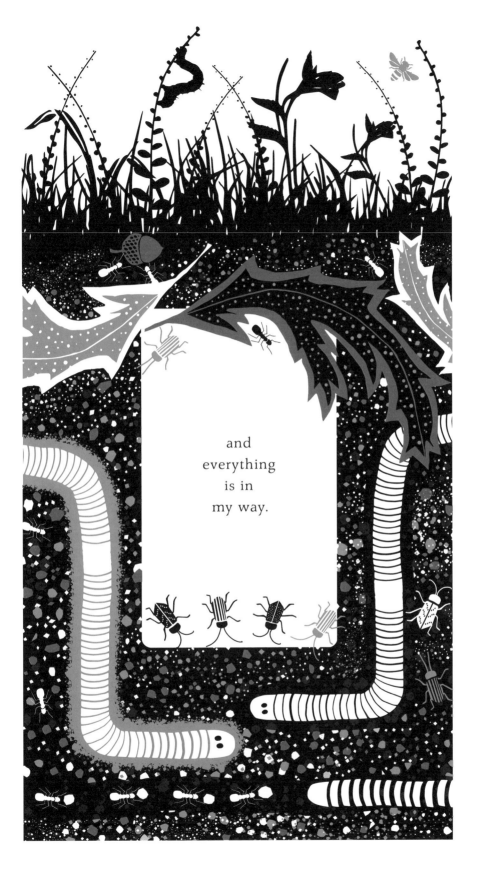

and
everything
is in
my way.

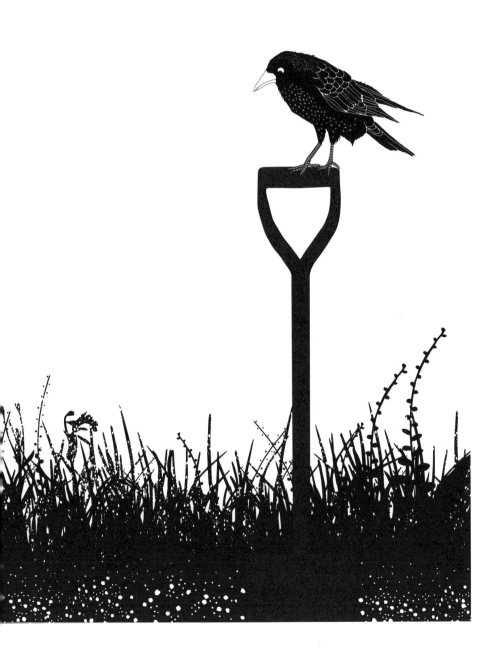

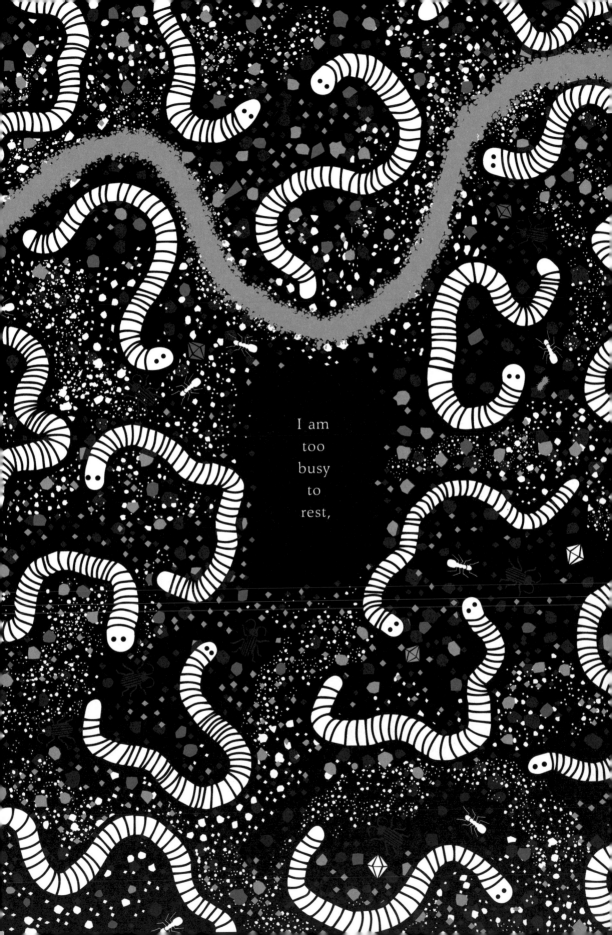

I am
too
busy
to
rest,

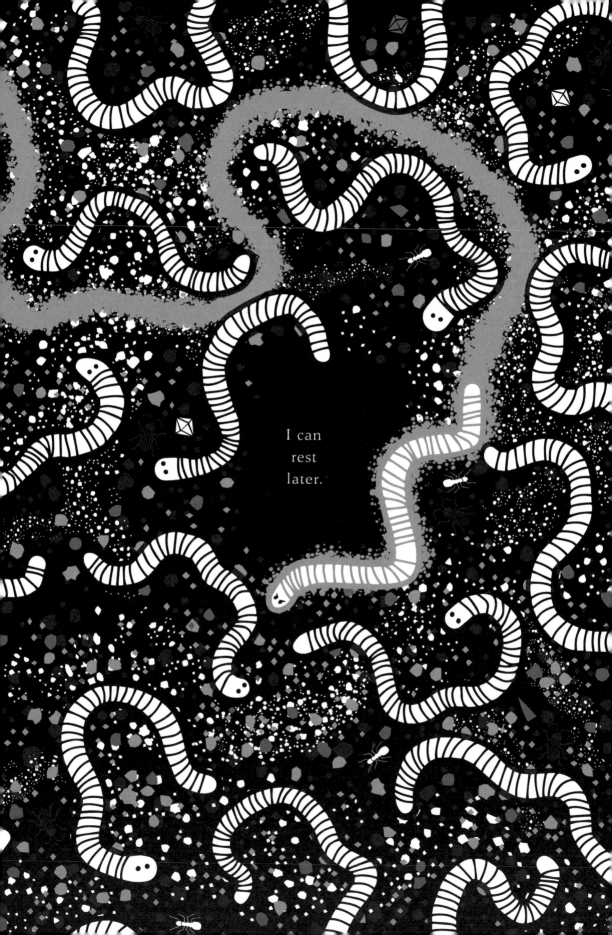

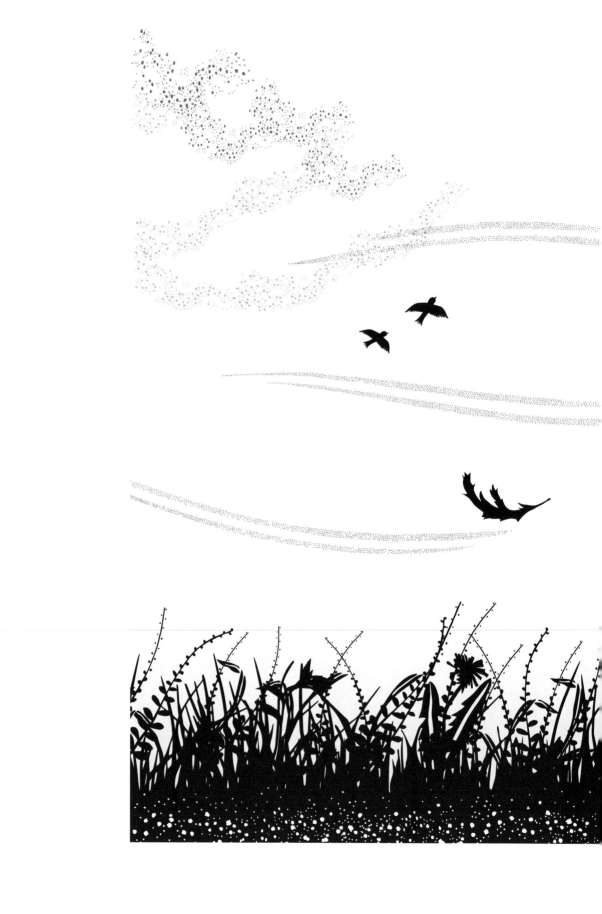

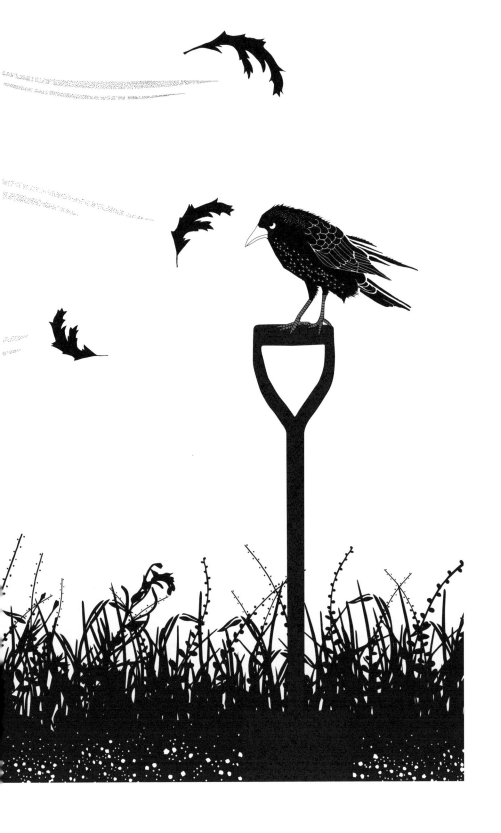

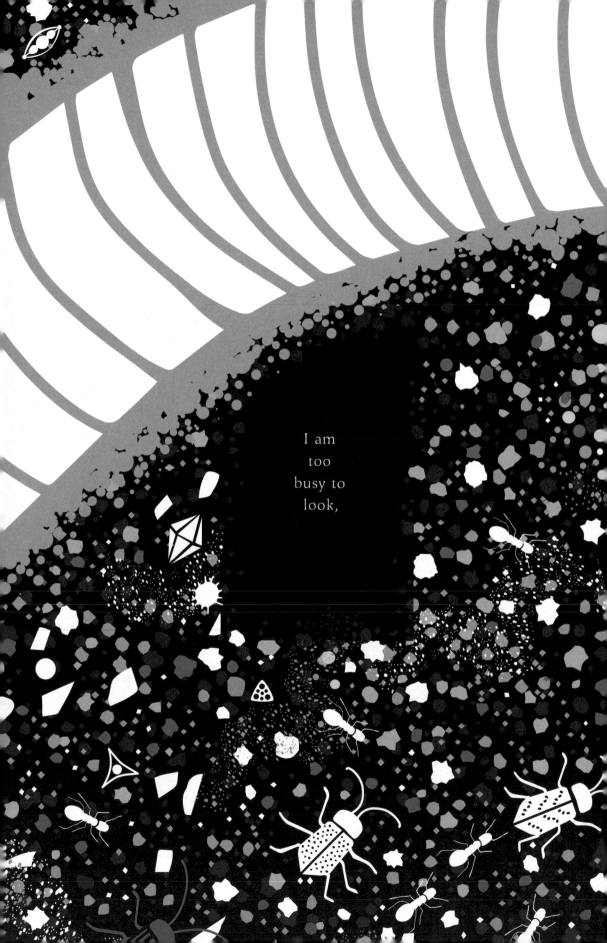

I am
too
busy to
look,

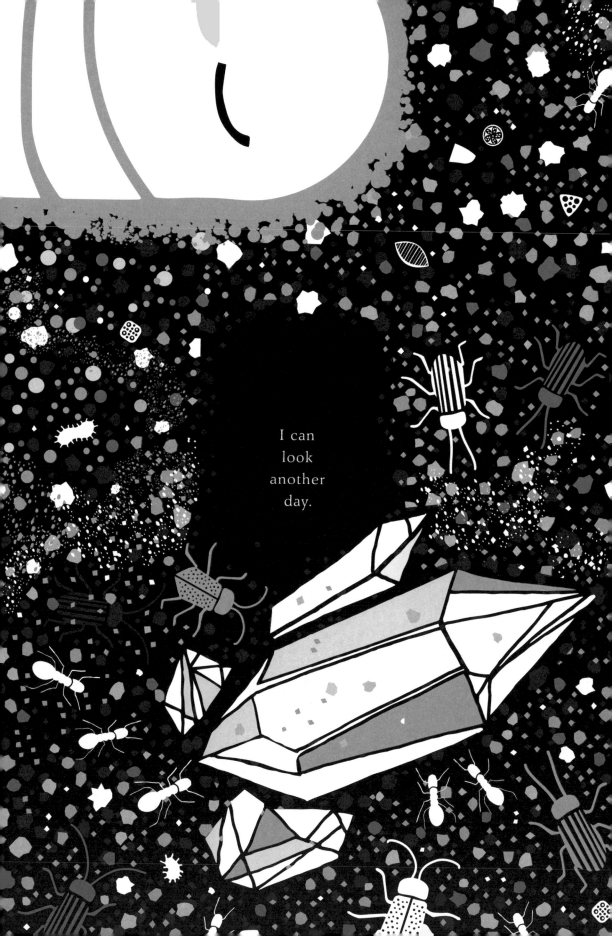

I can
look
another
day.

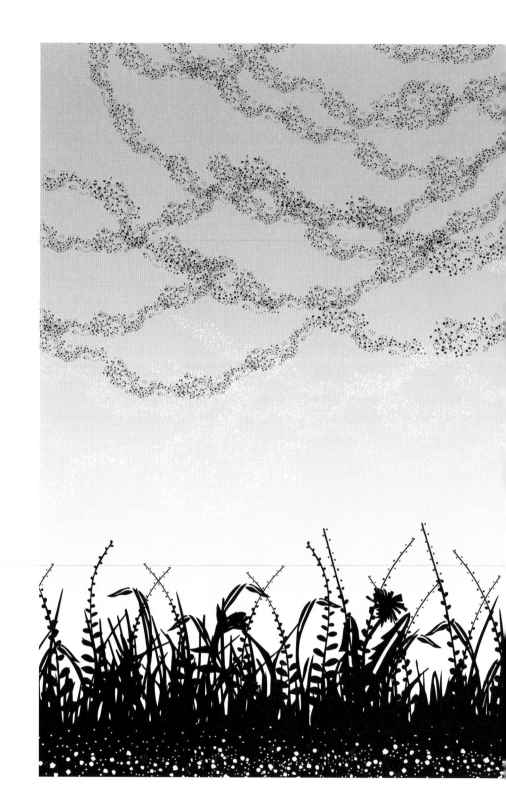

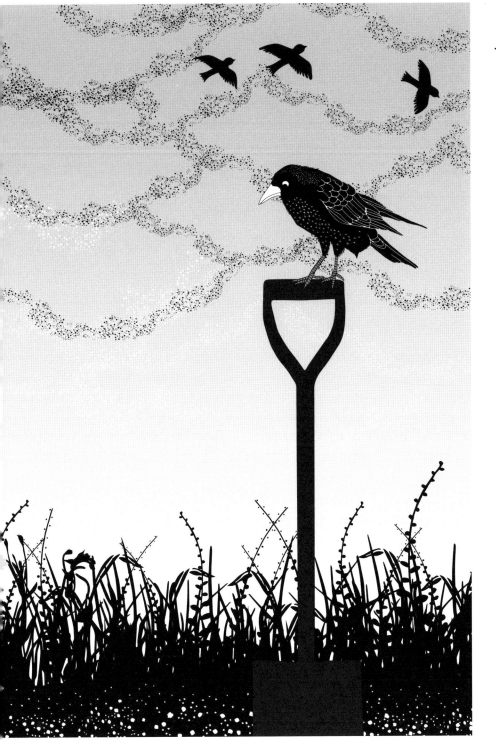

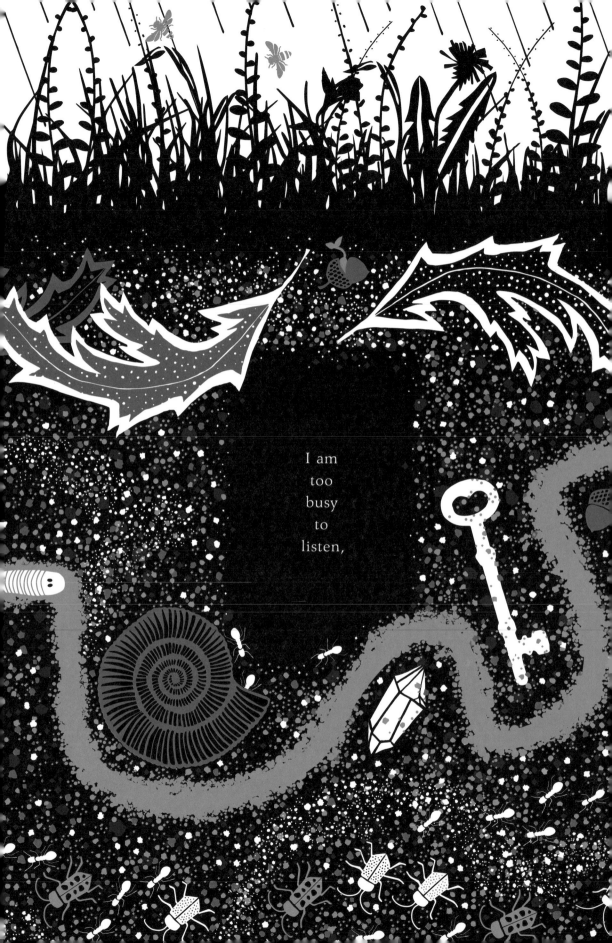

I am
too
busy
to
listen,

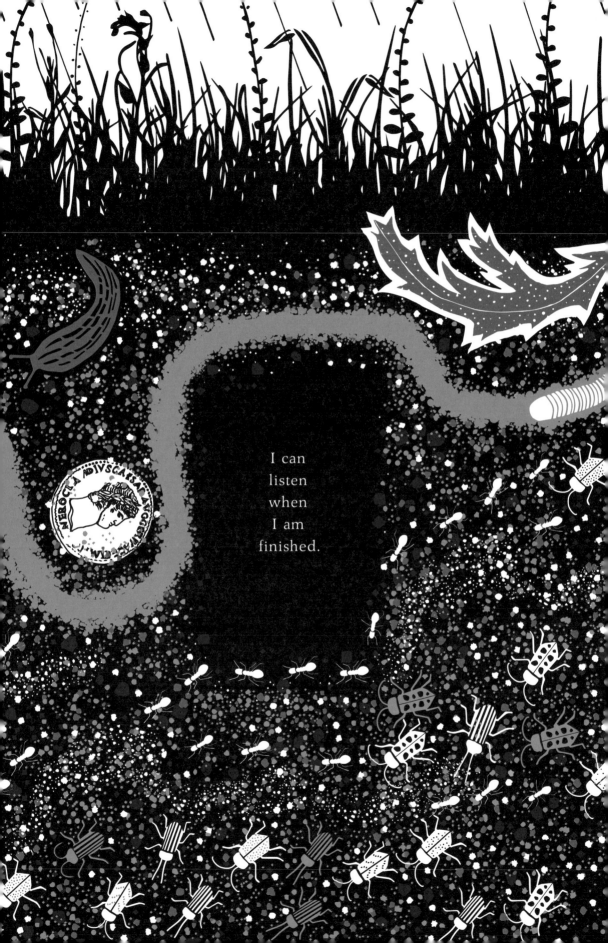

I can
listen
when
I am
finished.

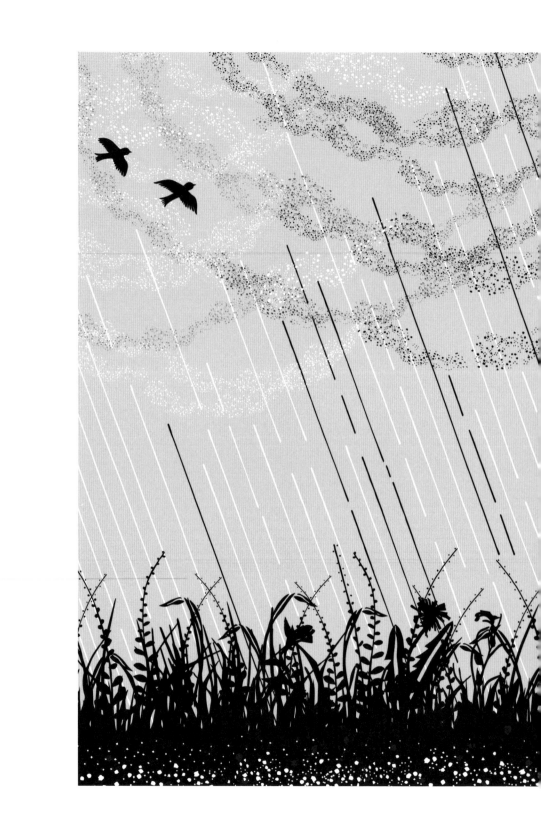

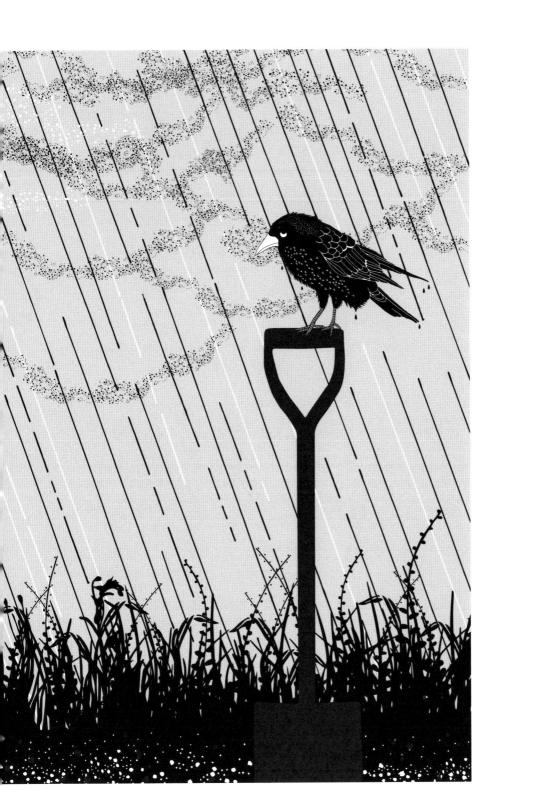

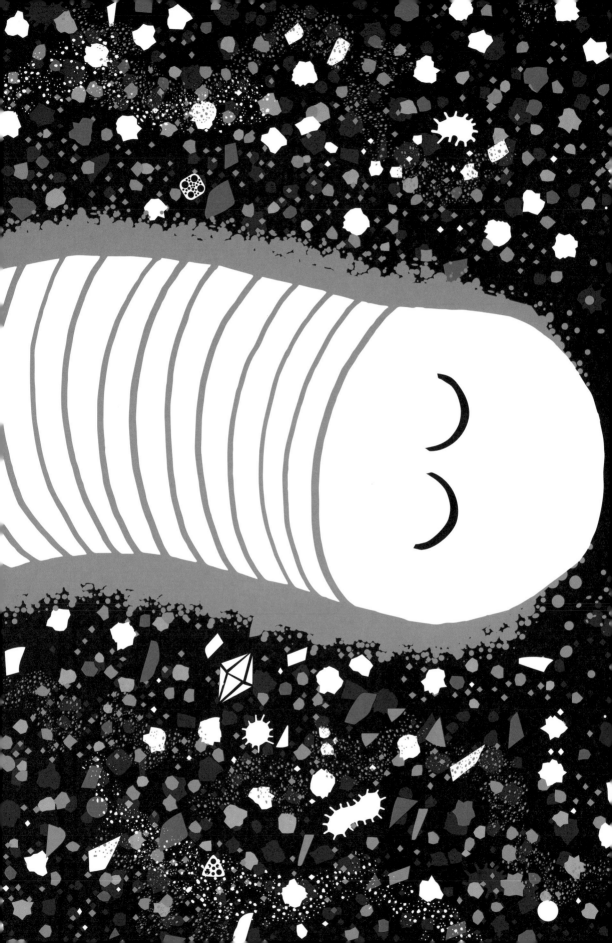

But
I dream
of a place.

A space
with
nothing.

A place
where
I can be
truly
alone.

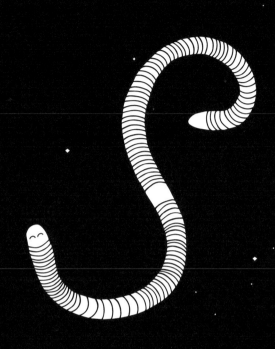

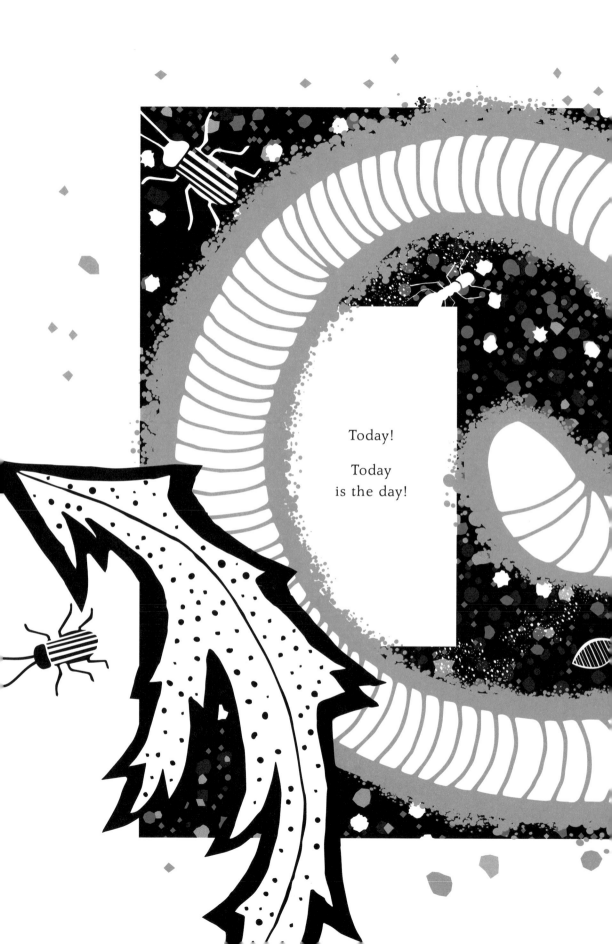

Today!

Today
is the day!

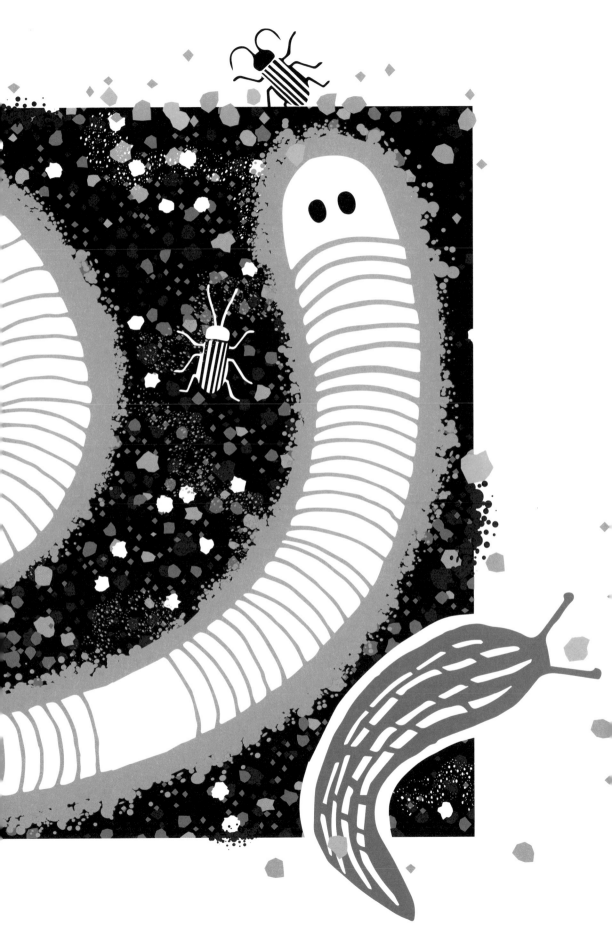

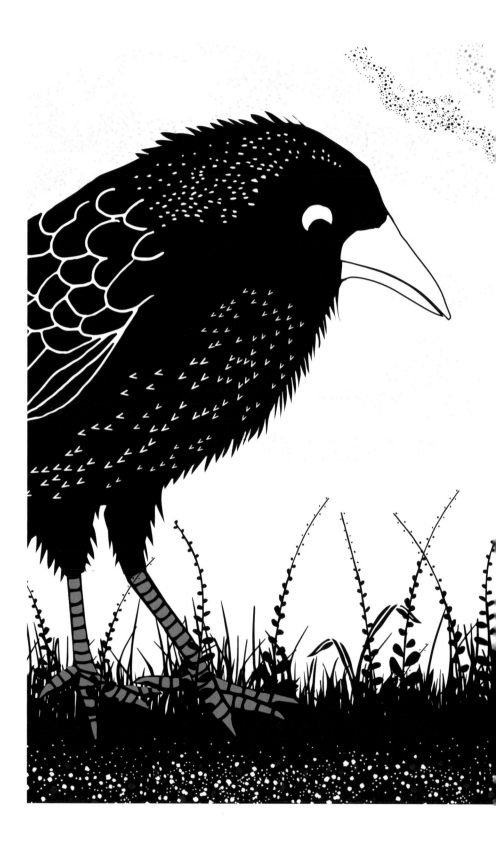

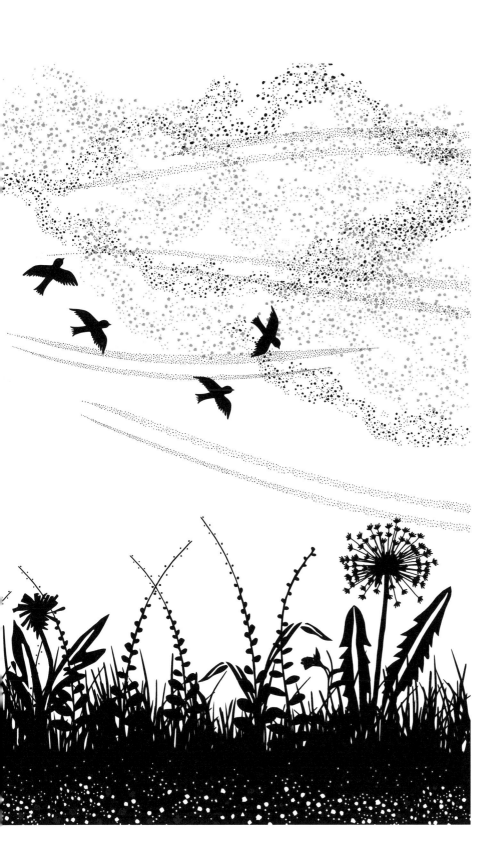

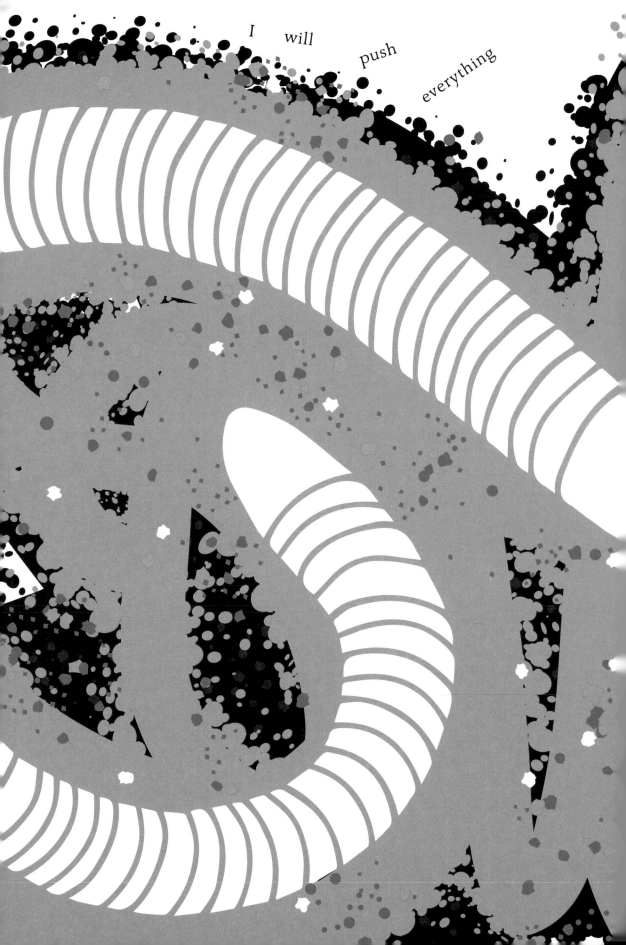

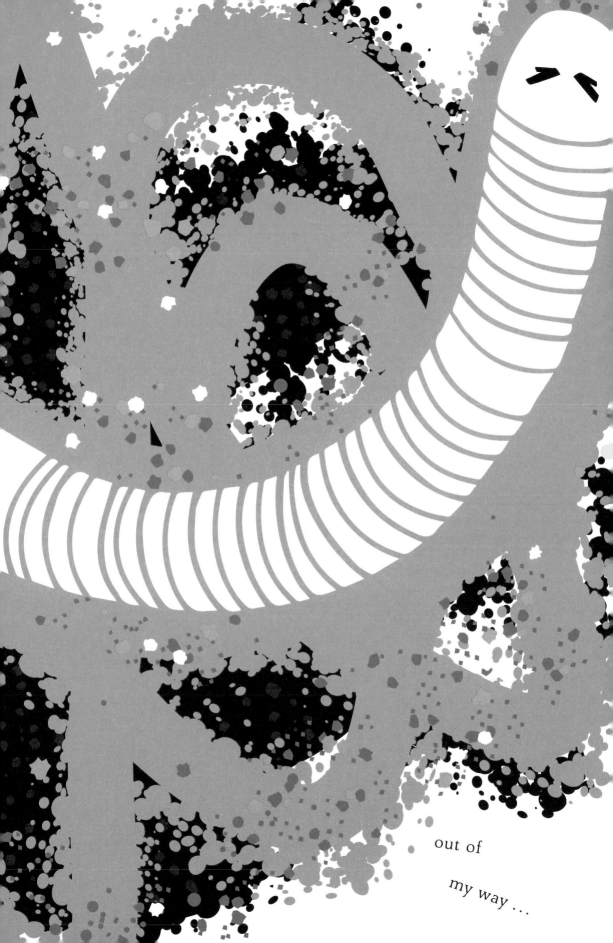

out of

my way . . .

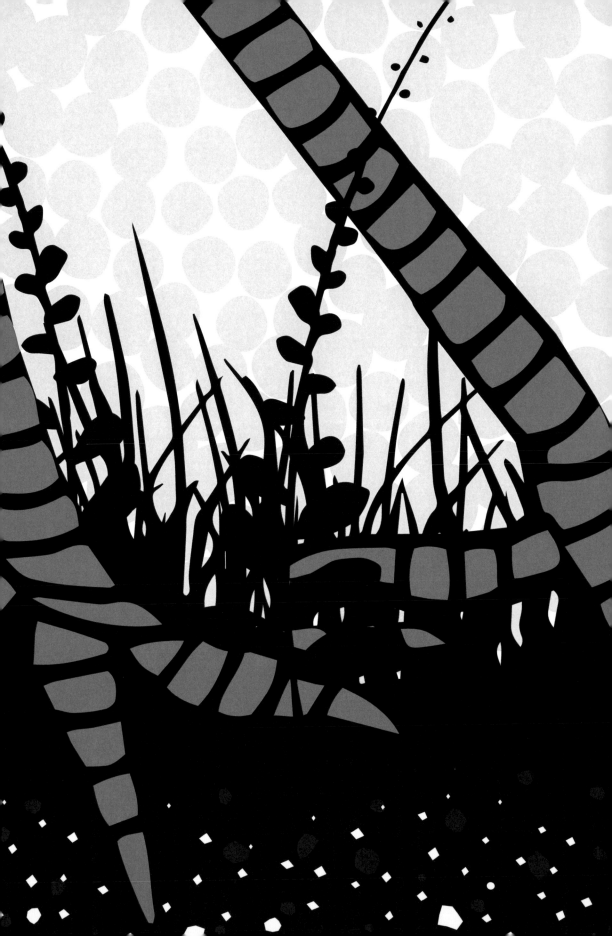

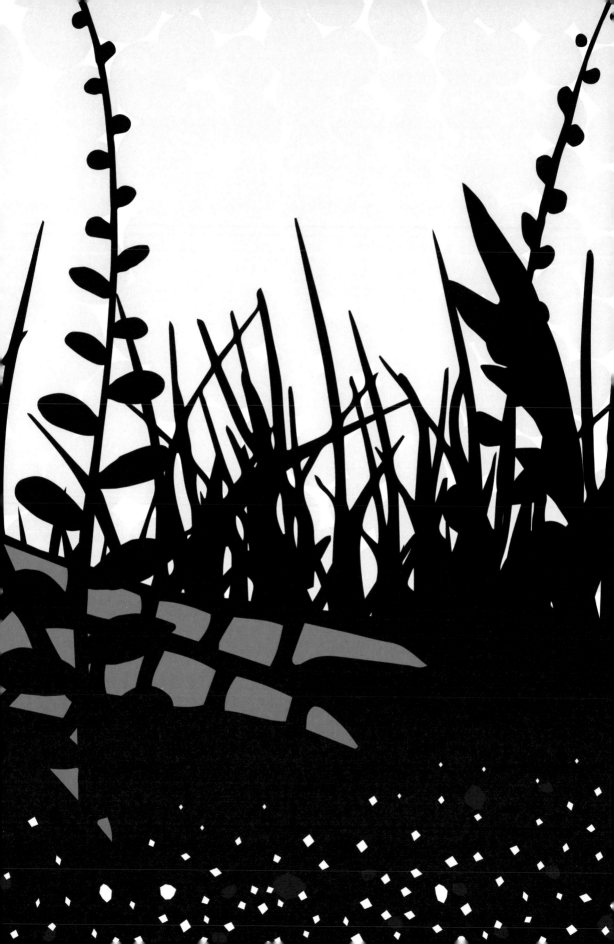

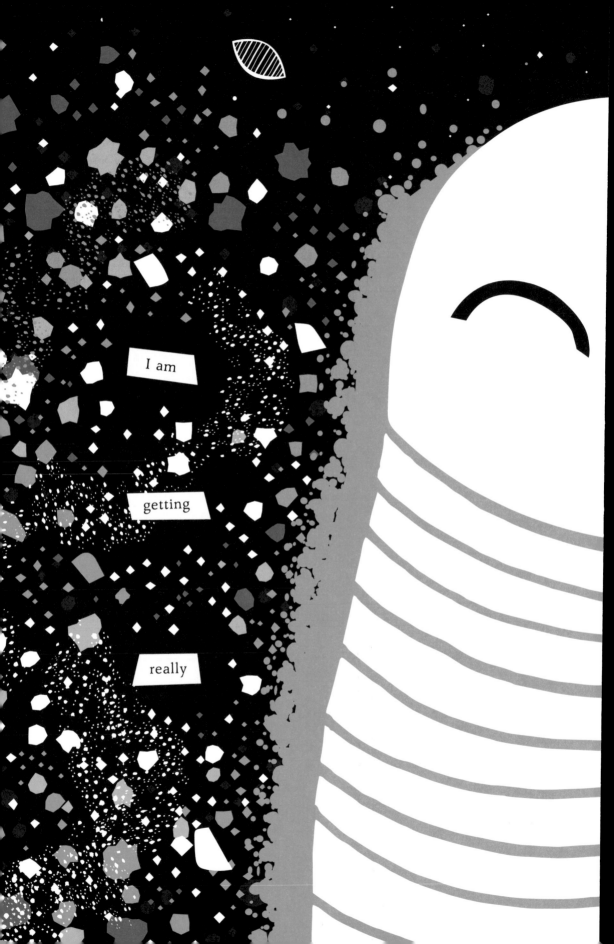

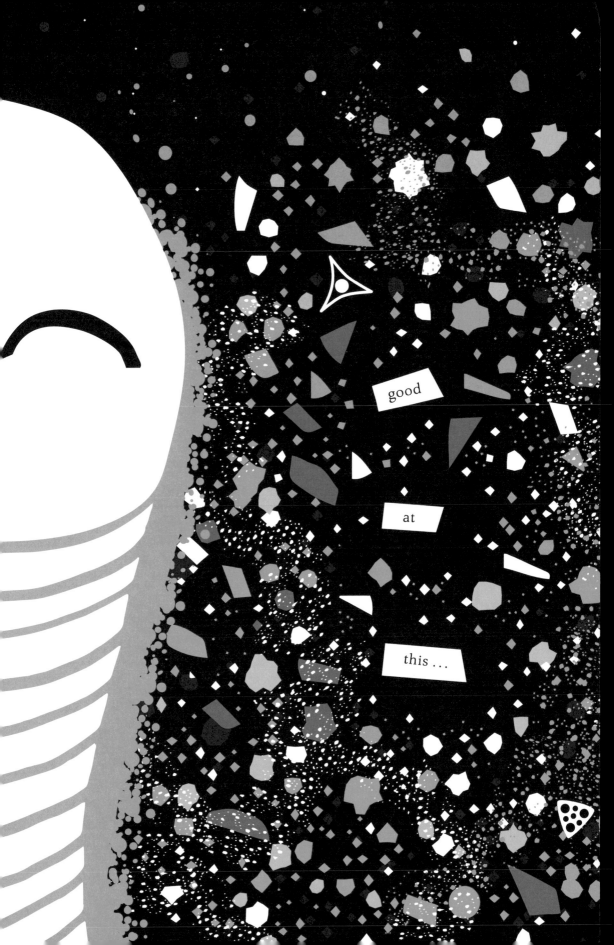

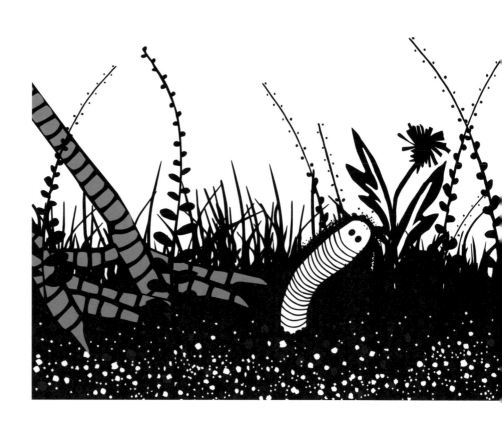

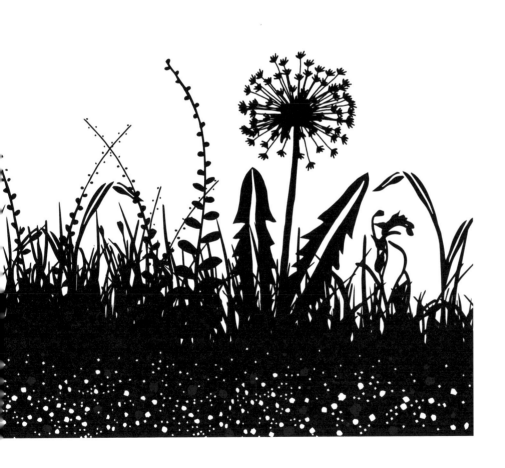

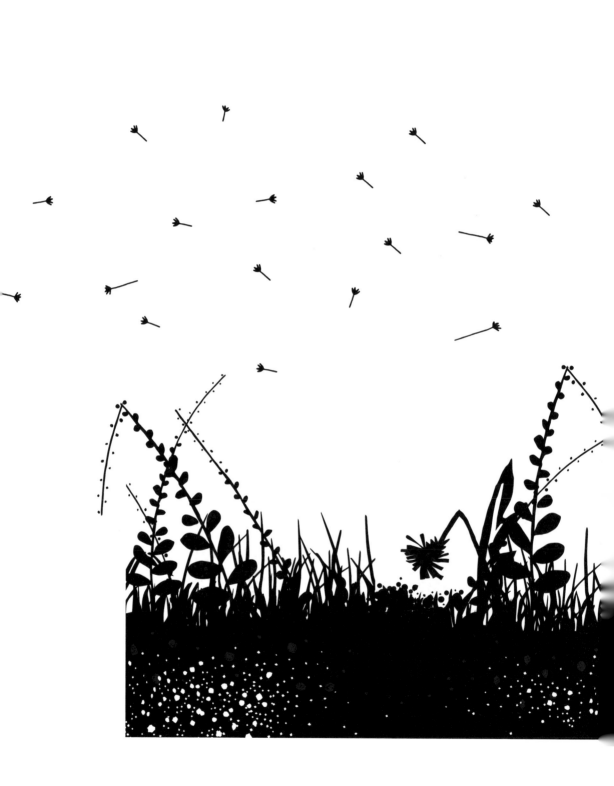

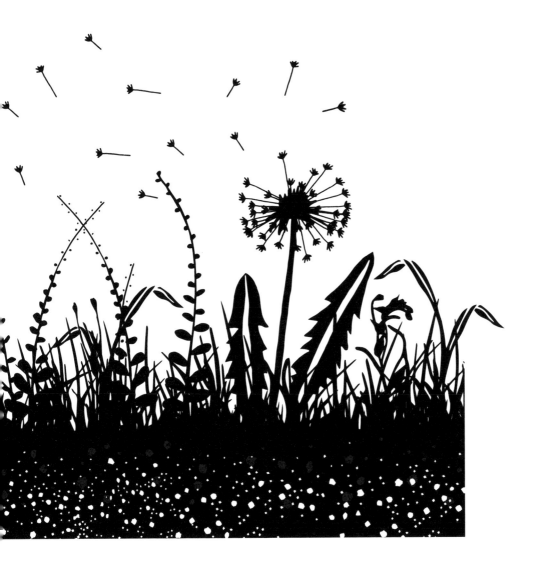

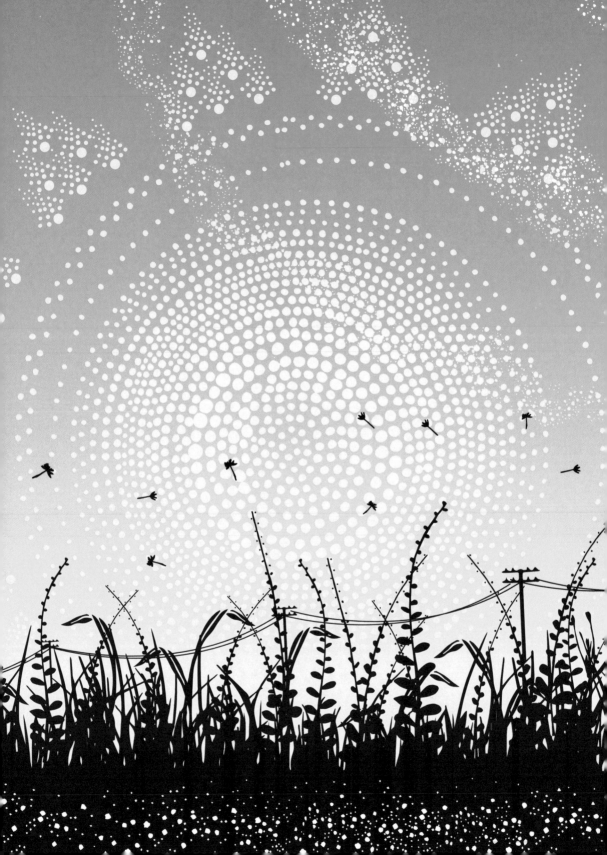

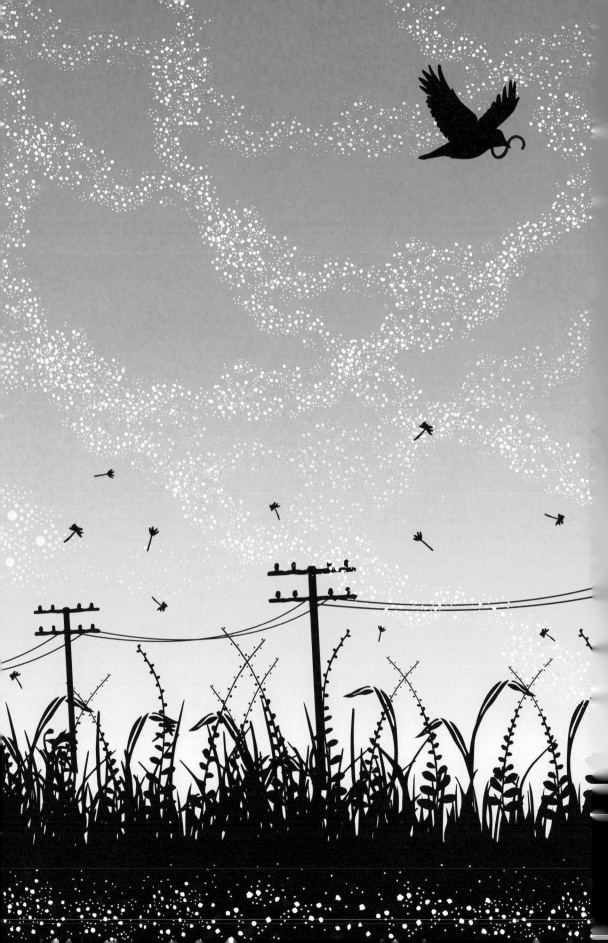

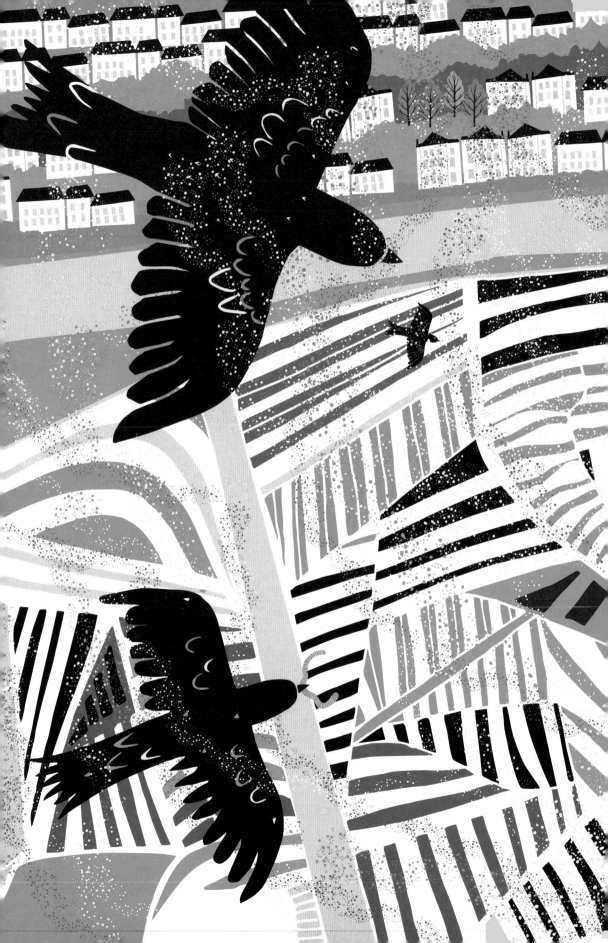

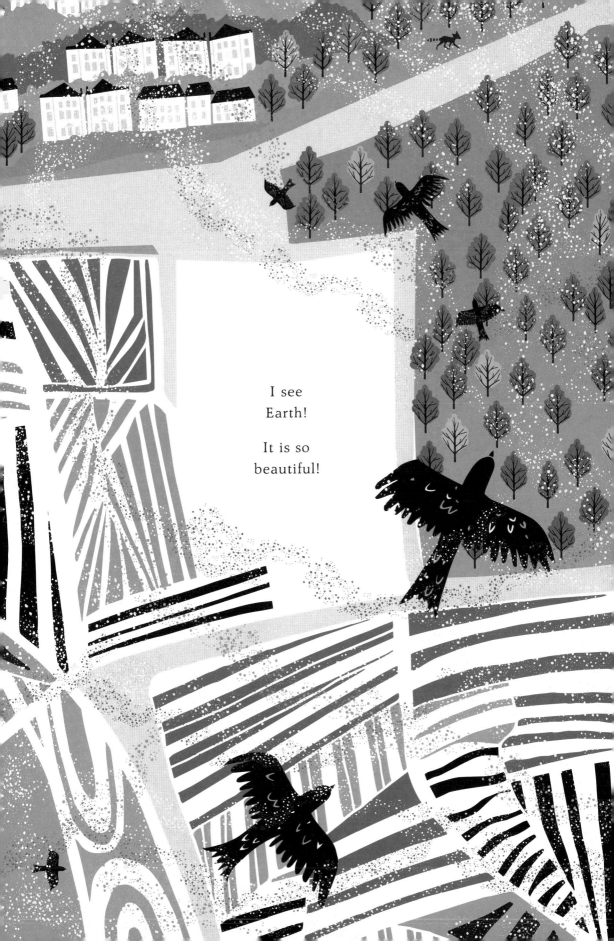

I see
Earth!

It is so
beautiful!

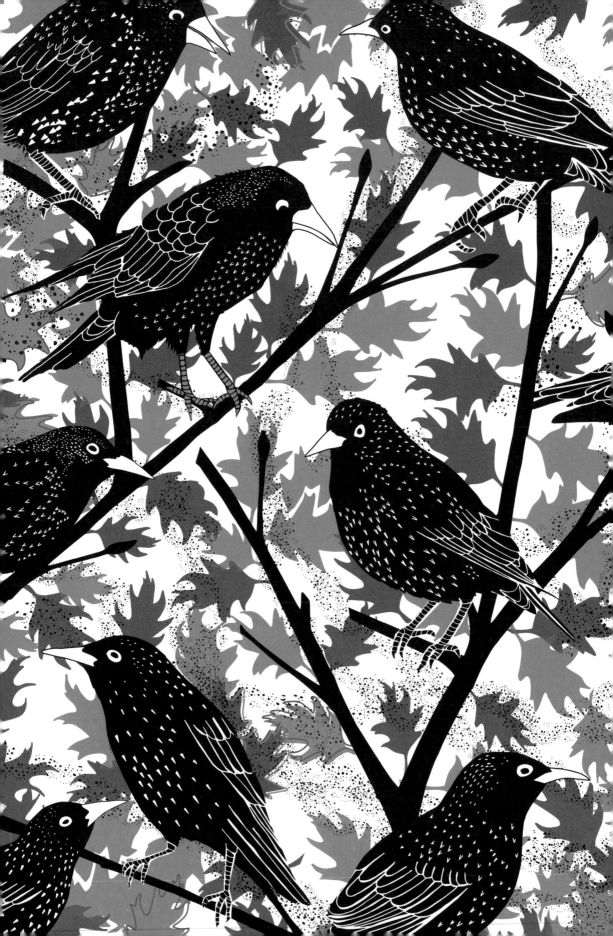

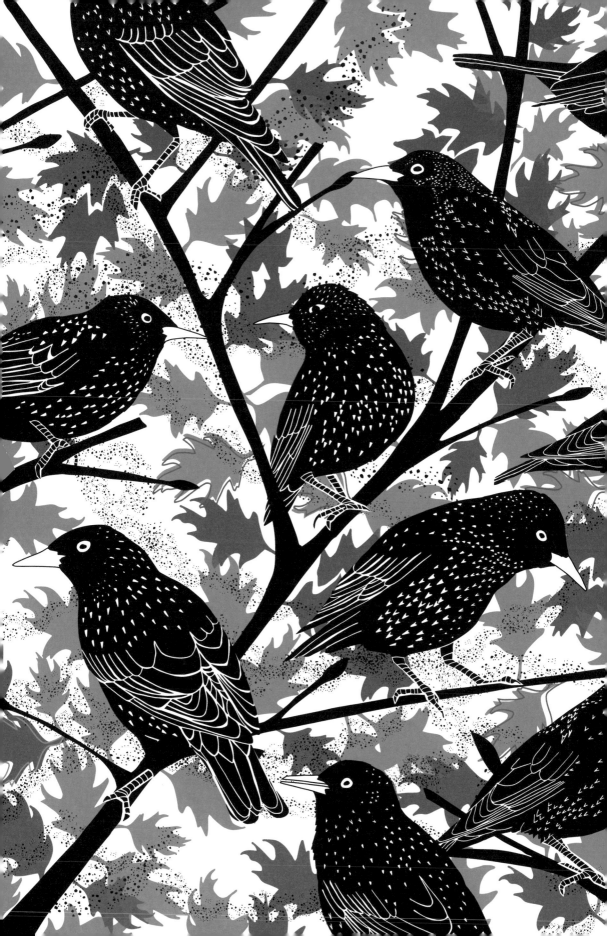

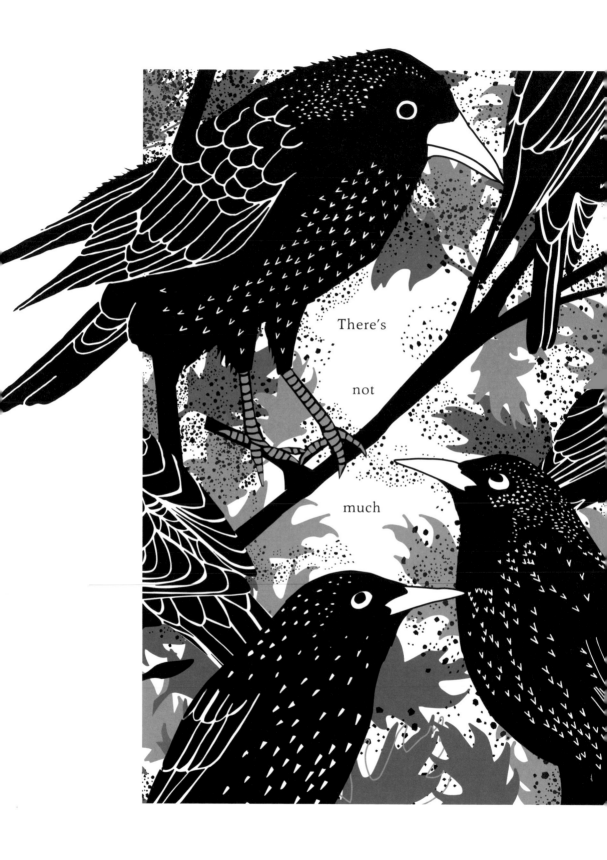

There's

not

much

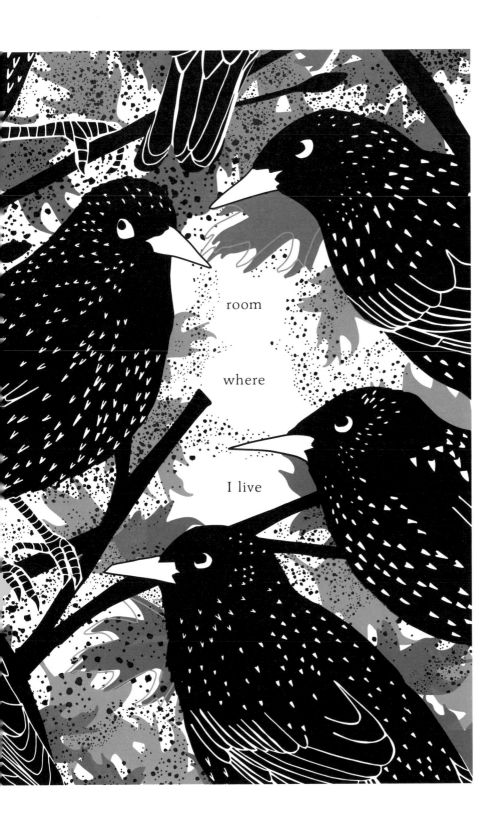

room

where

I live

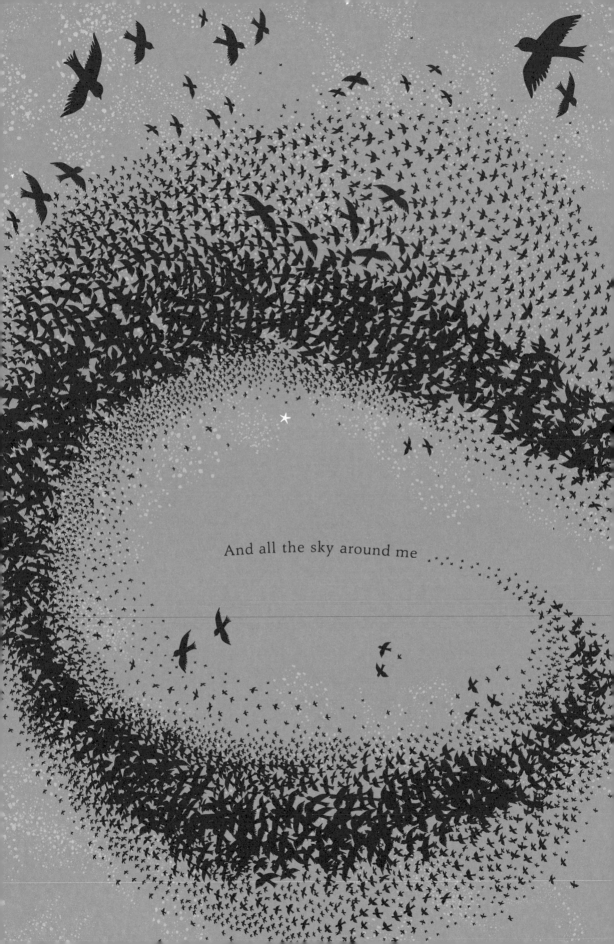

And all the sky around me

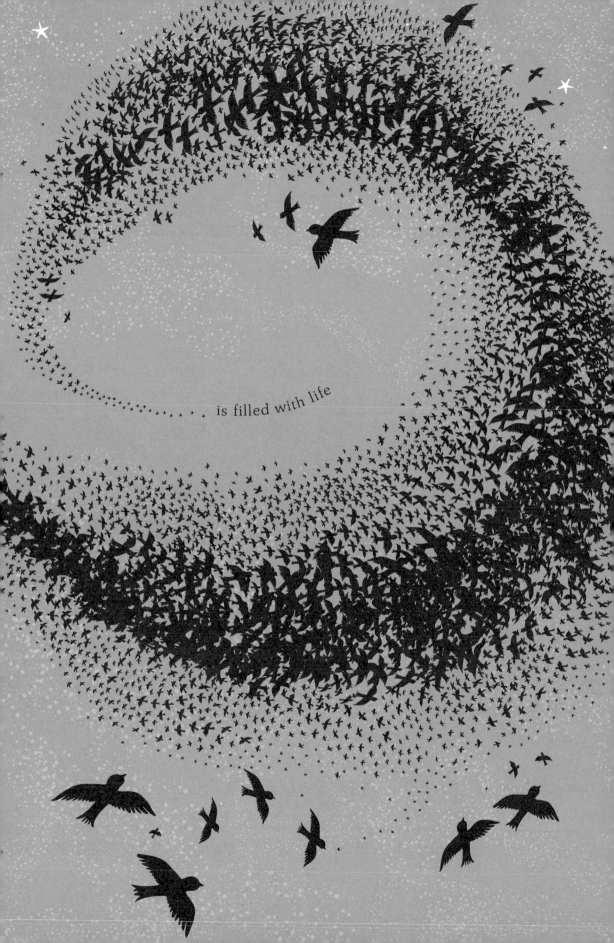

is filled with life

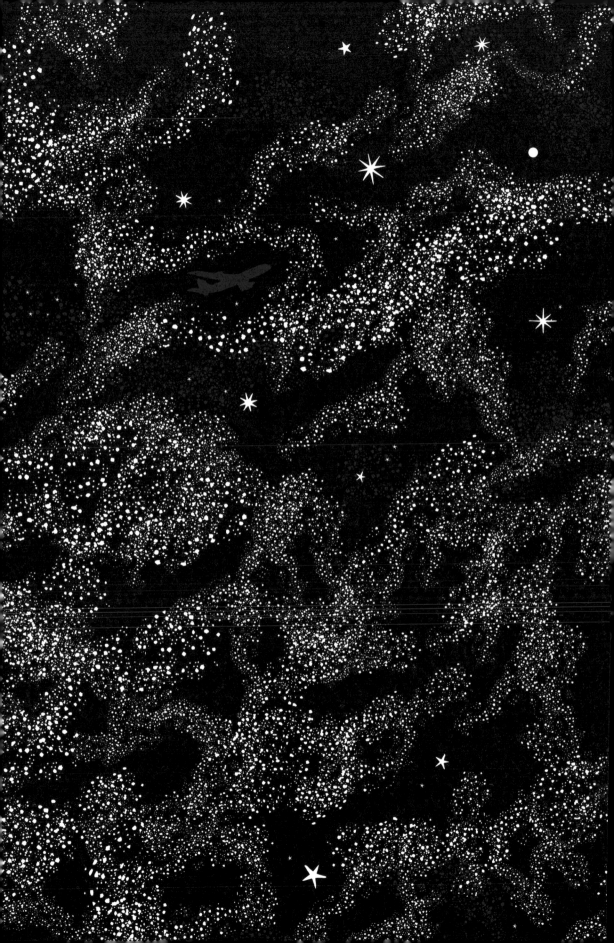

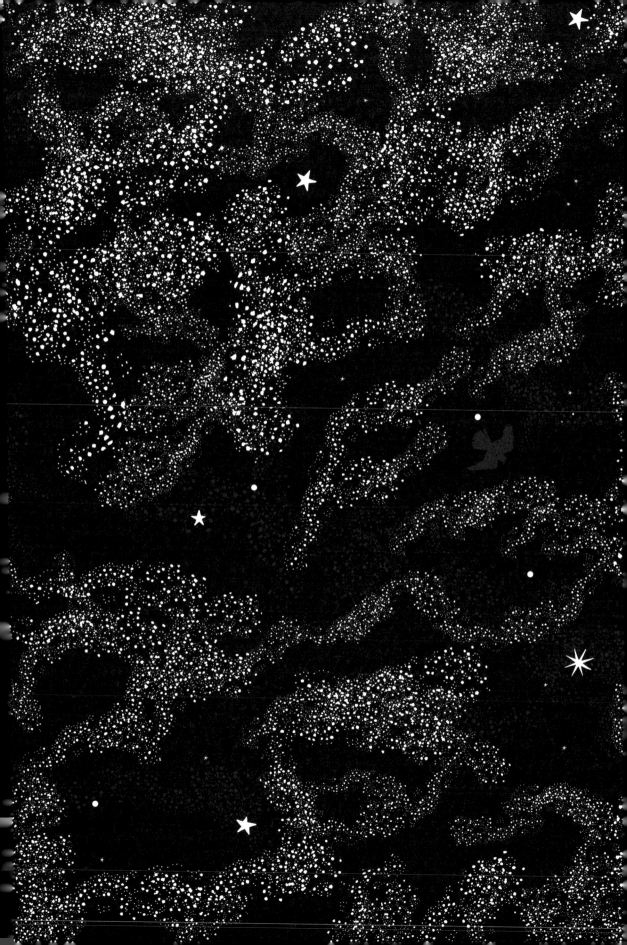

and
life can
be full of
endless
possibility
. . .

PENGUIN BOOKS

An imprint of Penguin Random House LLC
375 Hudson Street
New York, New York 10014
penguin.com

First published 2017

Illustrations by Coralie Bickford-Smith

ISBN 978-0-14-313286-8 (hardcover)

Set in Agfa Wile 12pt/16pt by Coralie Bickford-Smith

Printed in Italy by Graphicom Srl on Munken Pure Rough

1 3 5 7 9 10 8 6 4 2

Thank you
Abigail
Bickford-Smith,
Helen Conford,
Jim Stoddart,
David Mackintosh
and Viki Ottewil.

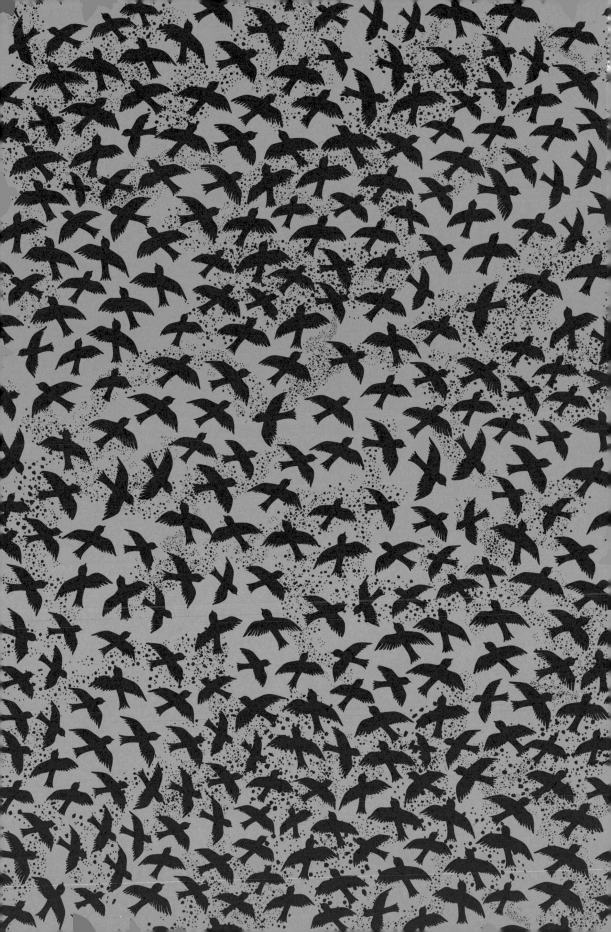